Books by Jan Baross
Available on Amazon.com

Fiction: Novel: *"Jose Builds a Woman"*
First place for fiction—National Kay Snow Award, Walden Fellowship

Non-Fiction: Travel Series:
"Ms. Baross Goes to Paris"
"Ms. Baross Goes to Mexico: San Miguel de Allende"
"Ms. Baross Goes to Cuba"

Coloring Book:
The Cuban Coloring Book

Text, cover and interior artwork copyright© 2016 by Jan Baross.
All rights reserved.

No part of this book may be reproduced in any manner
and without permission from the author and publisher.

Cover drawings: Jan Baross
Cover and interior design: TJ Rockett

MPolo Press: Portland, Oregon
Publishers of award winning books

ISBN #978–1537576602
First edition

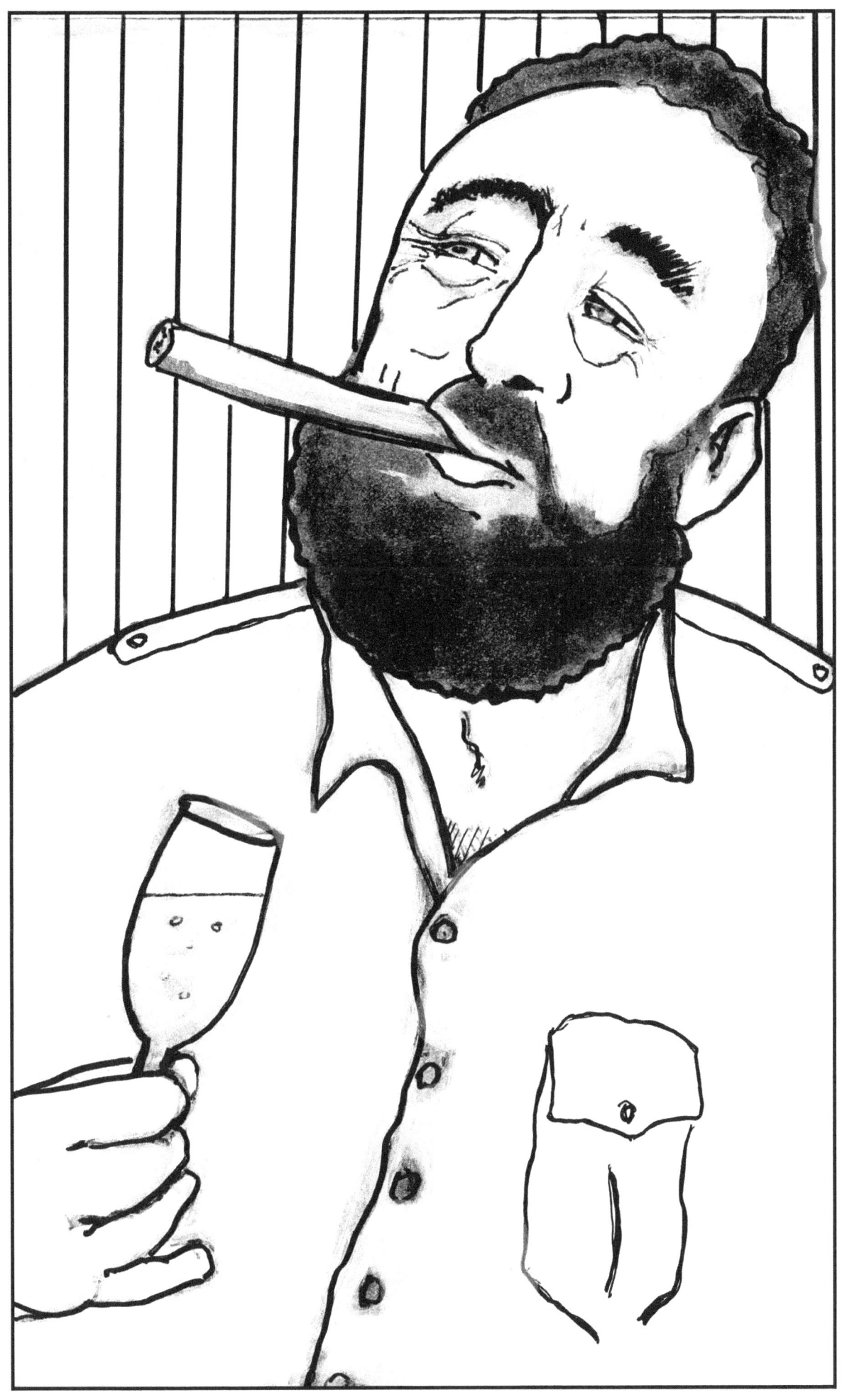

Welcome to the Revolution!
In business since 1959

Illustrated by Jan Baross

colored by:_____

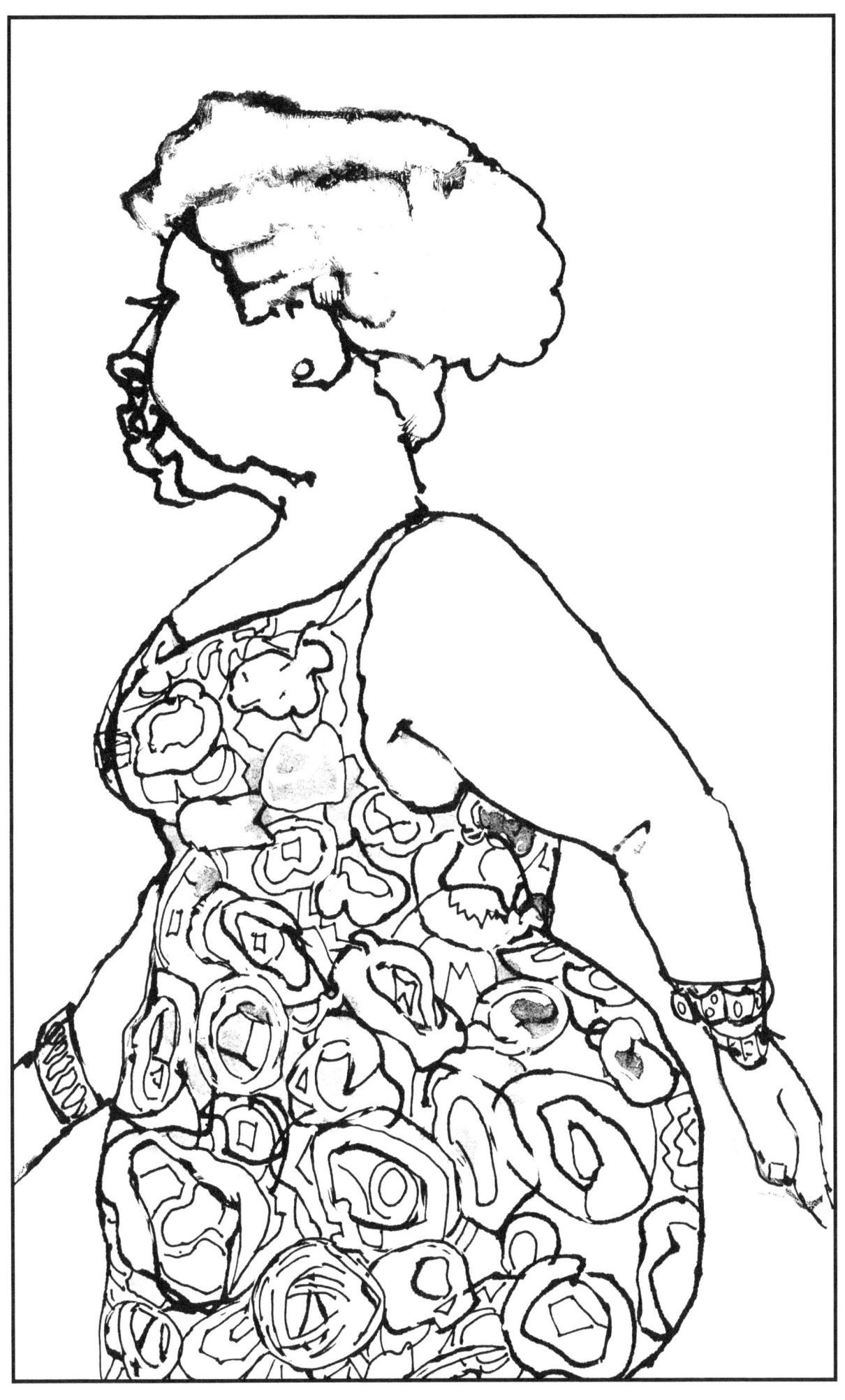

Early Morning Stroll To Work

Illustrated by Jan Baross

colored by:_____

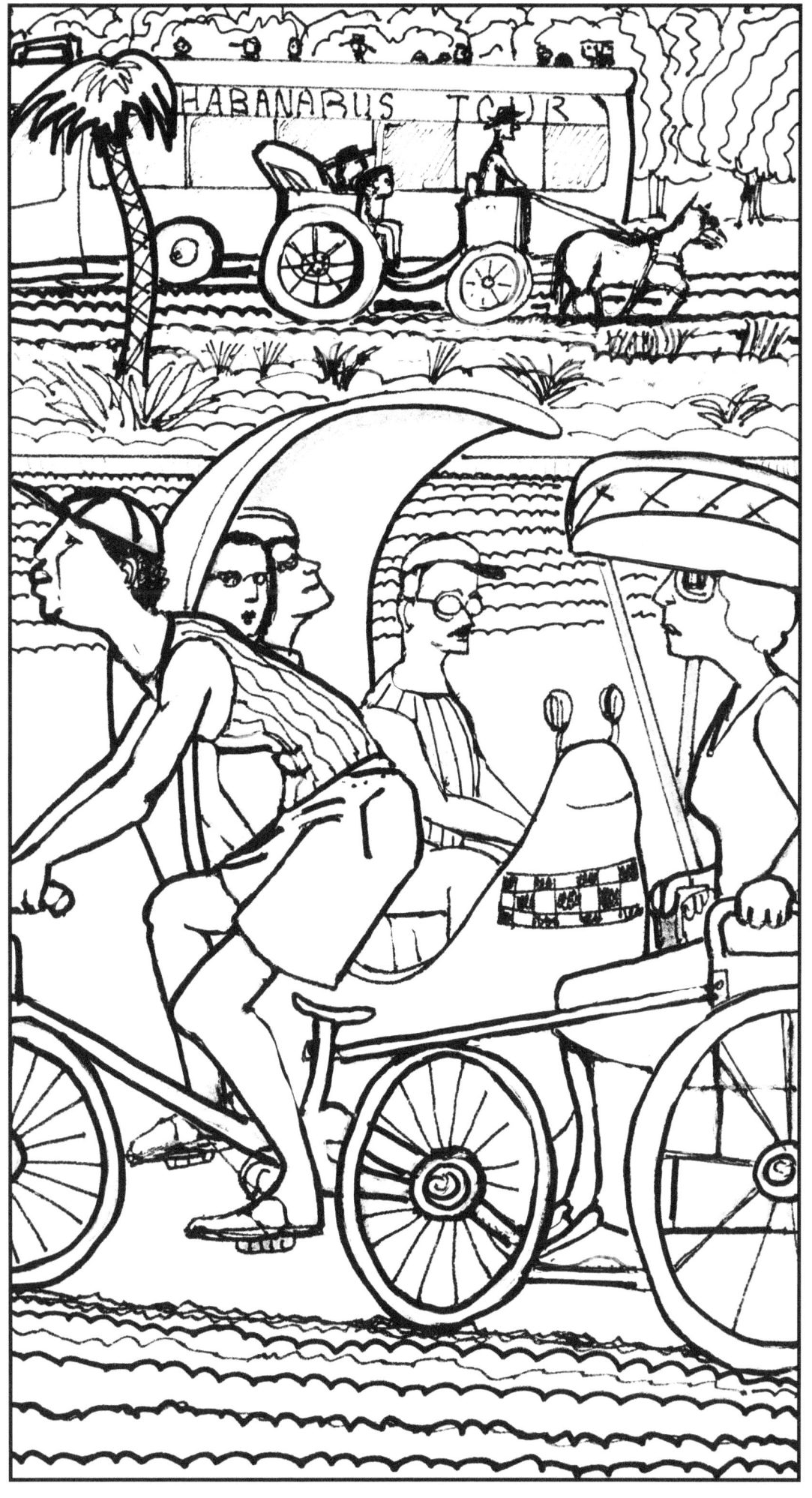

Deals on Wheels—Getting Around Havana

Illustrated by Jan Baross

colored by:_____

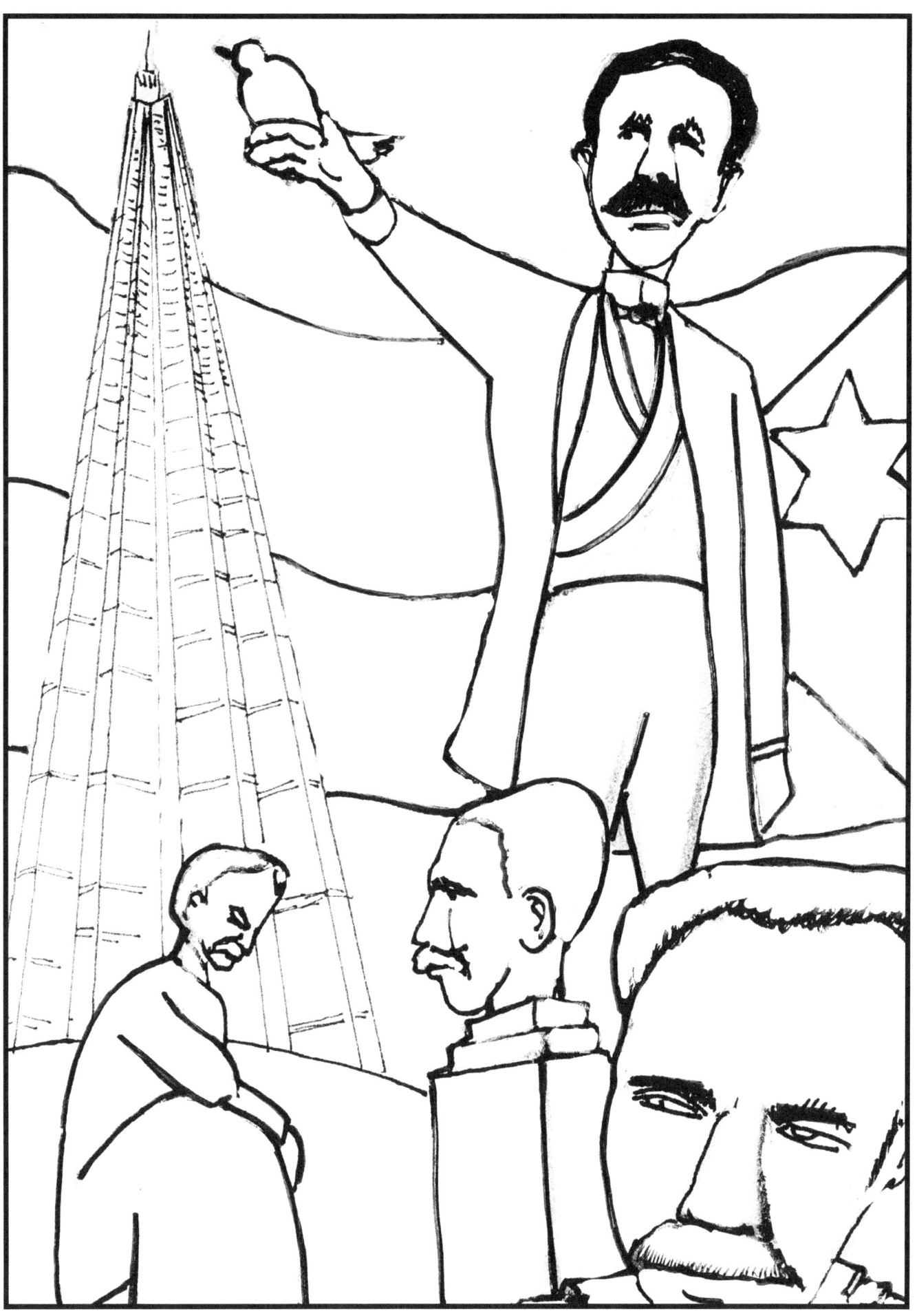

Revolution Square
Jose Martì—Poet Hero of the Revolution!

Illustrated by Jan Baross

colored by:_____

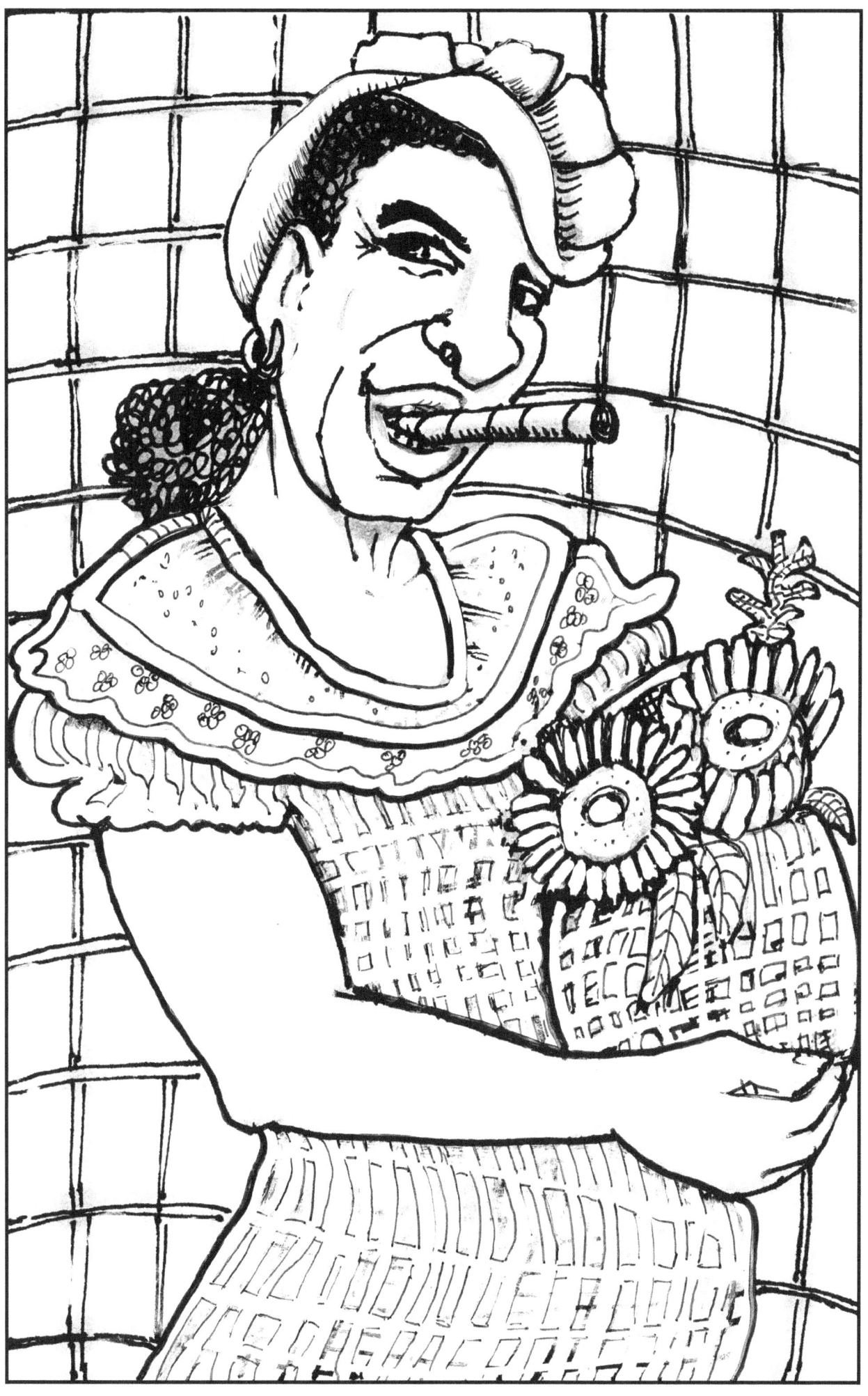

Plaza De Aramas
"Pay me and you can take a selfie!"

Illustrated by Jan Baross

colored by: _____

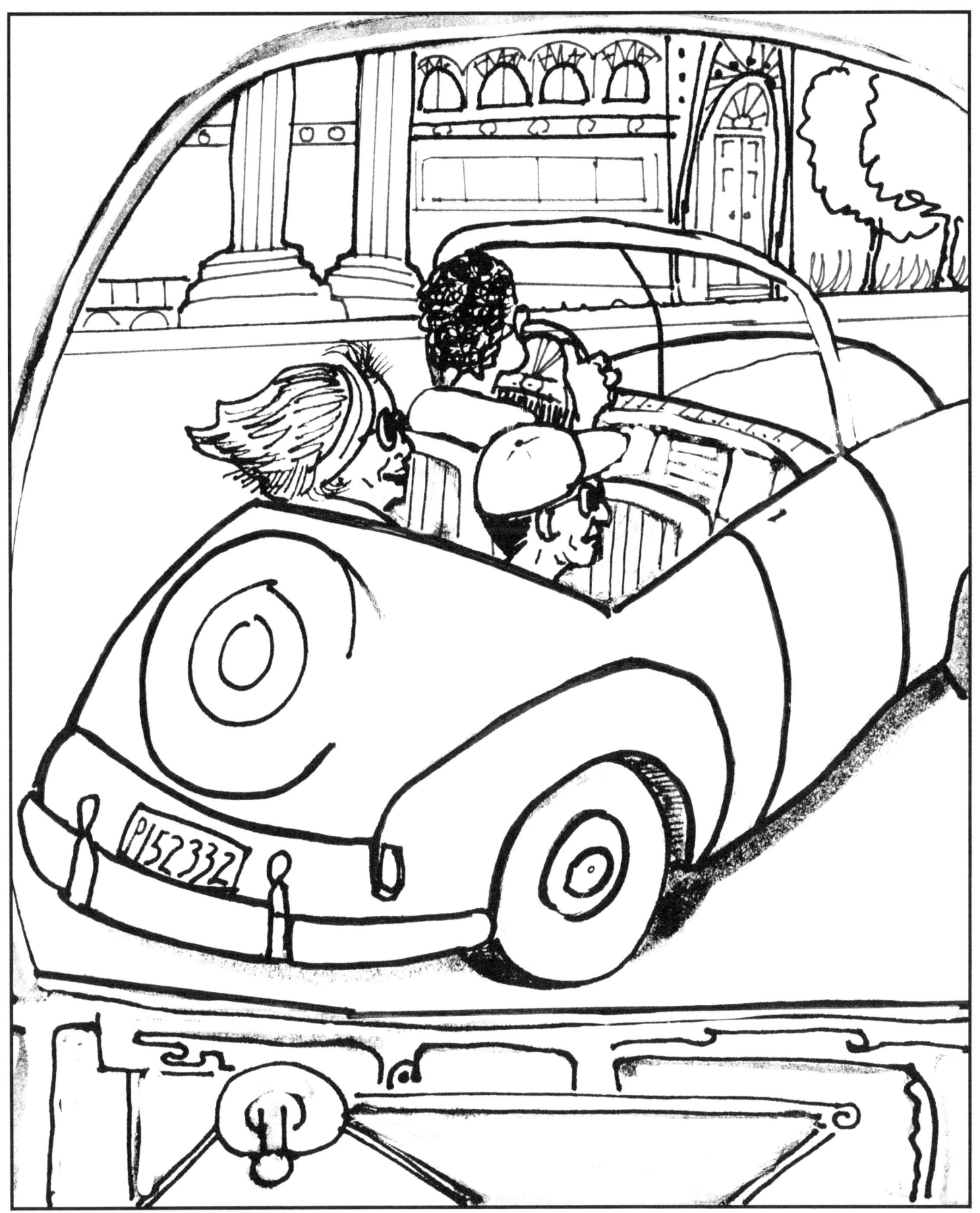

Hot Wheels in Havana

Illustrated by Jan Baross

colored by:_____

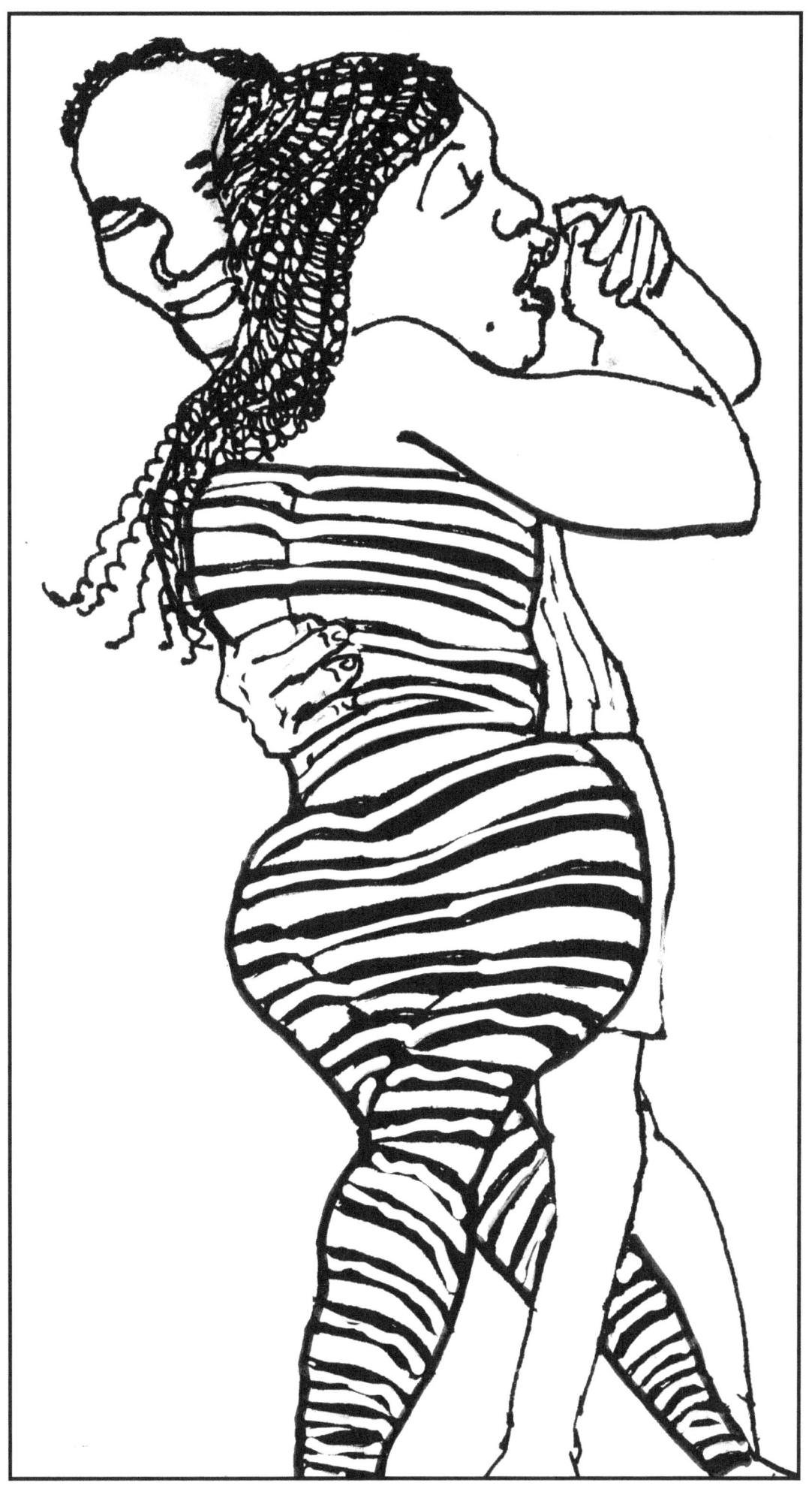

Dancing in Havana

Illustrated by Jan Baross

colored by:_____

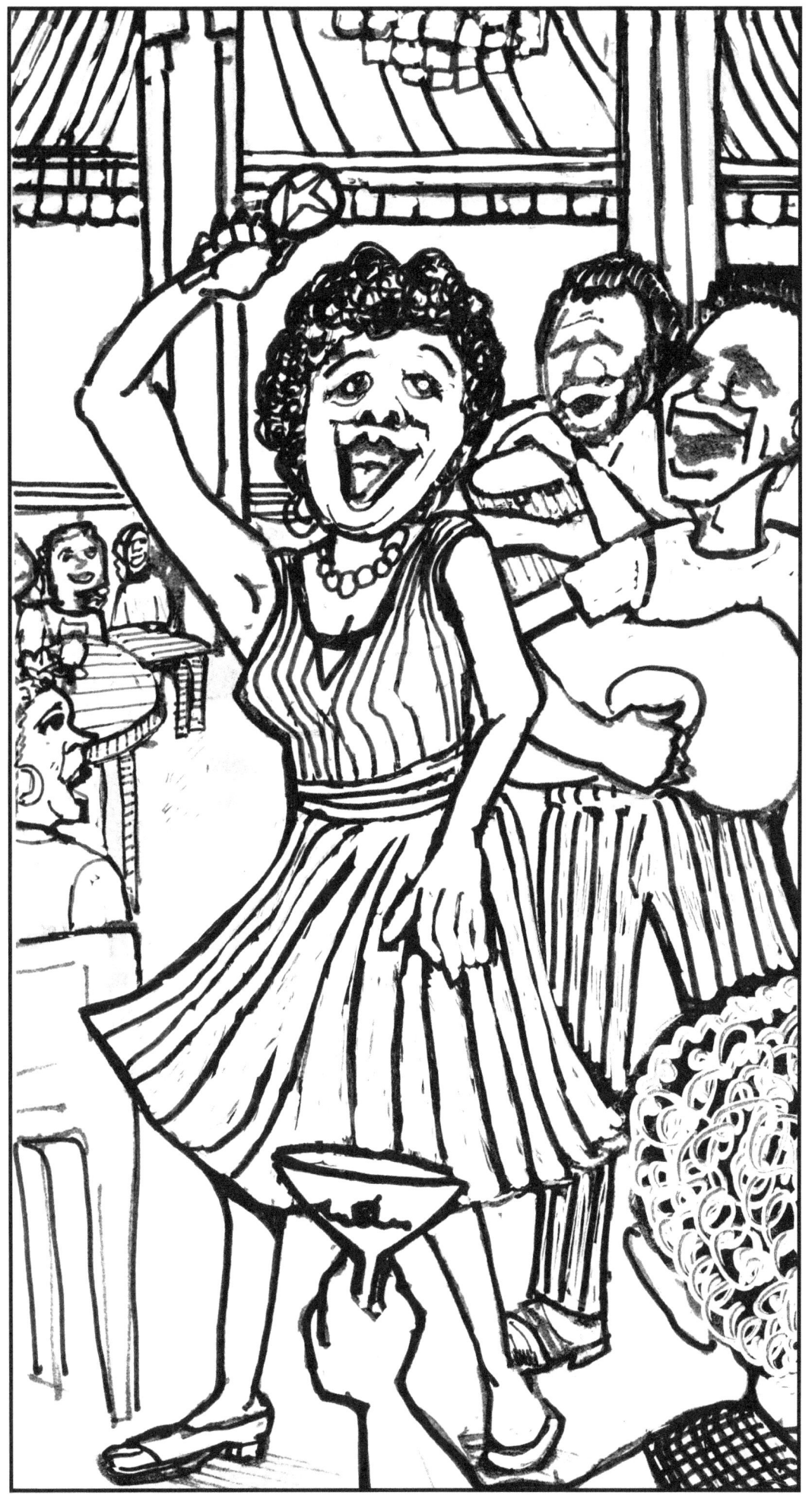

El Floridito
There's no bad music in Cuba!

Illustrated by Jan Baross

colored by: _____

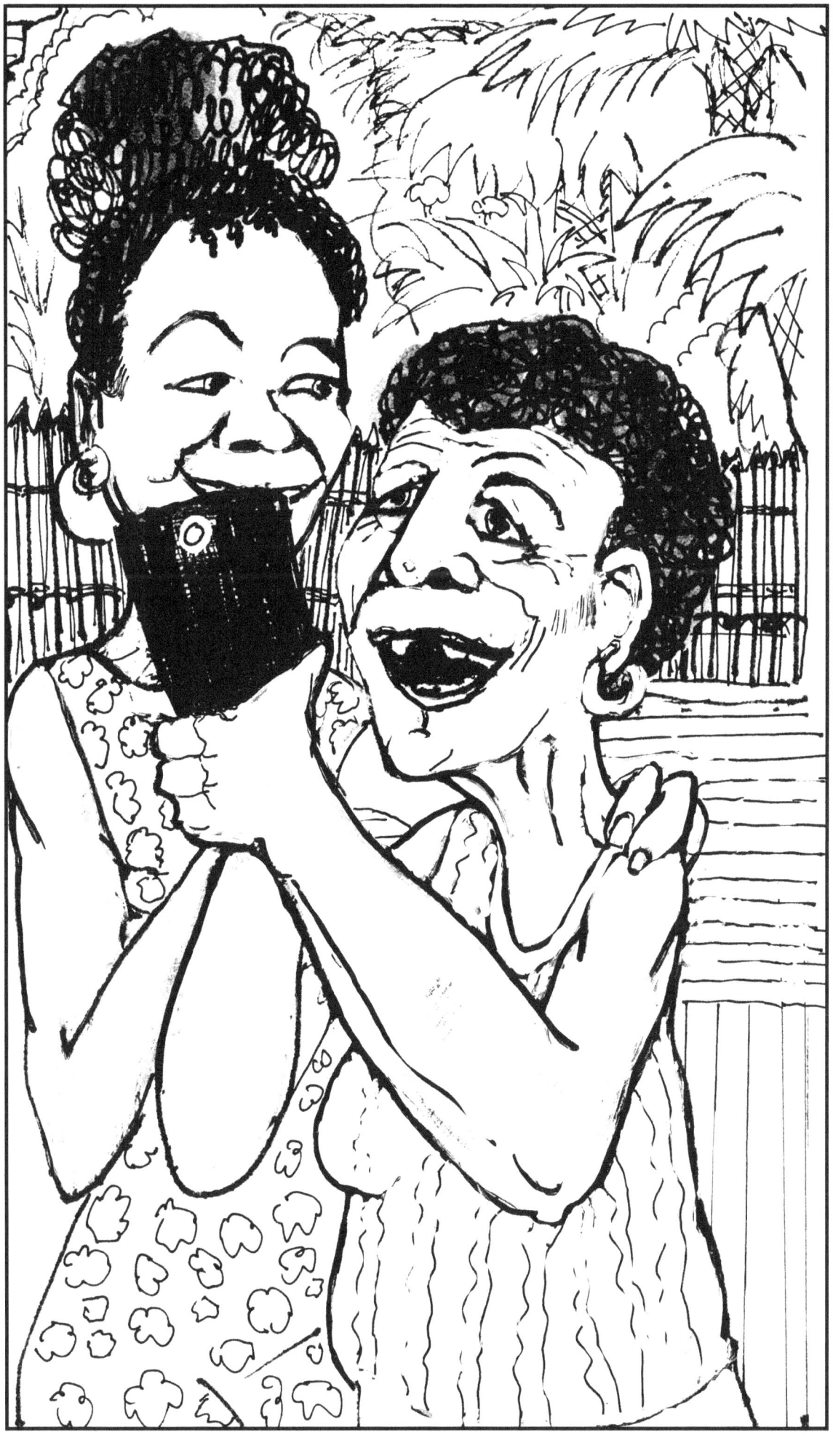

WiFi Grandma talks to U.S. Grandkids for the First Time!

Illustrated by Jan Baross

colored by:_____

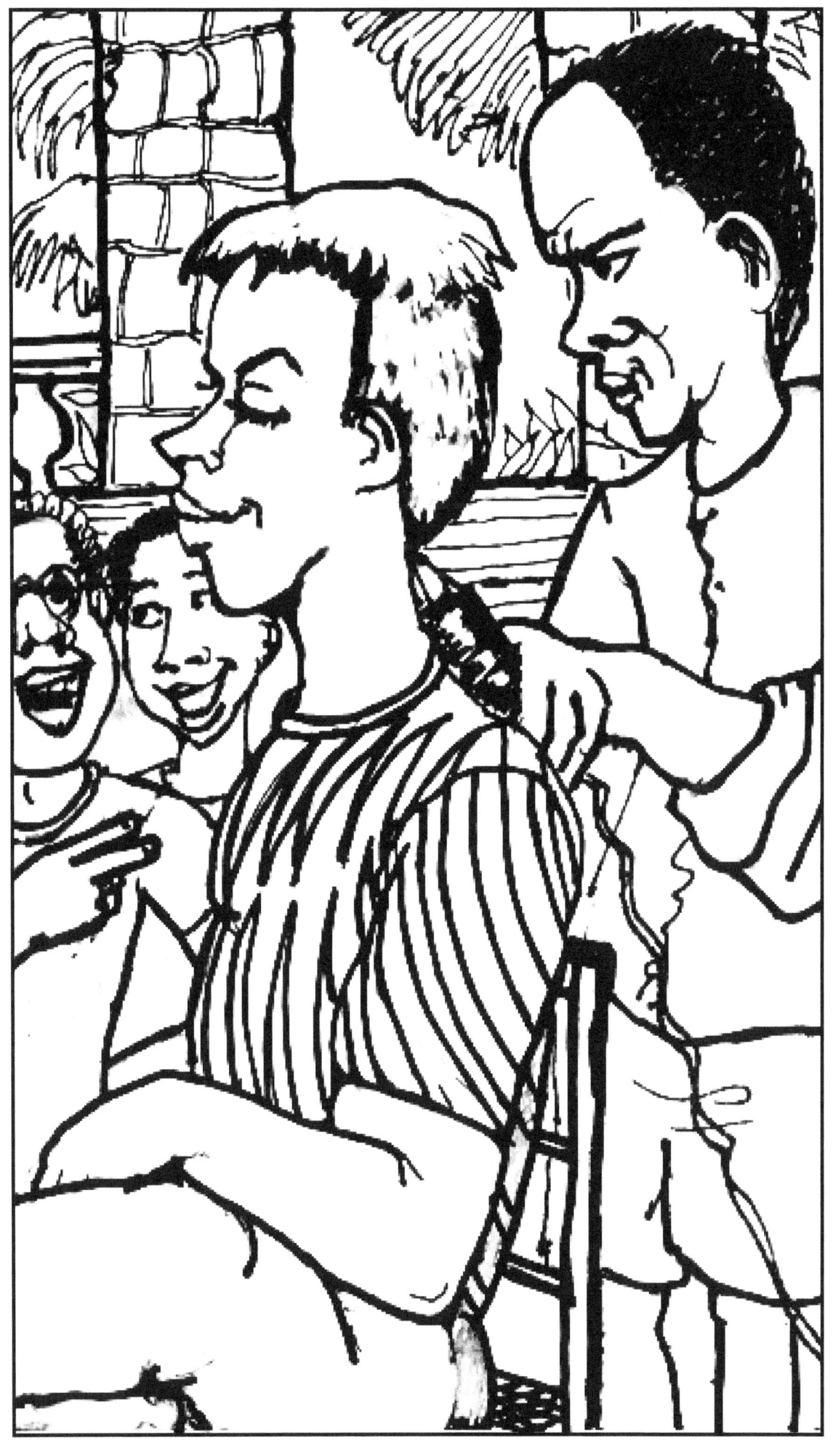

Haircuts on the Street

Illustrated by Jan Baross

colored by:_____

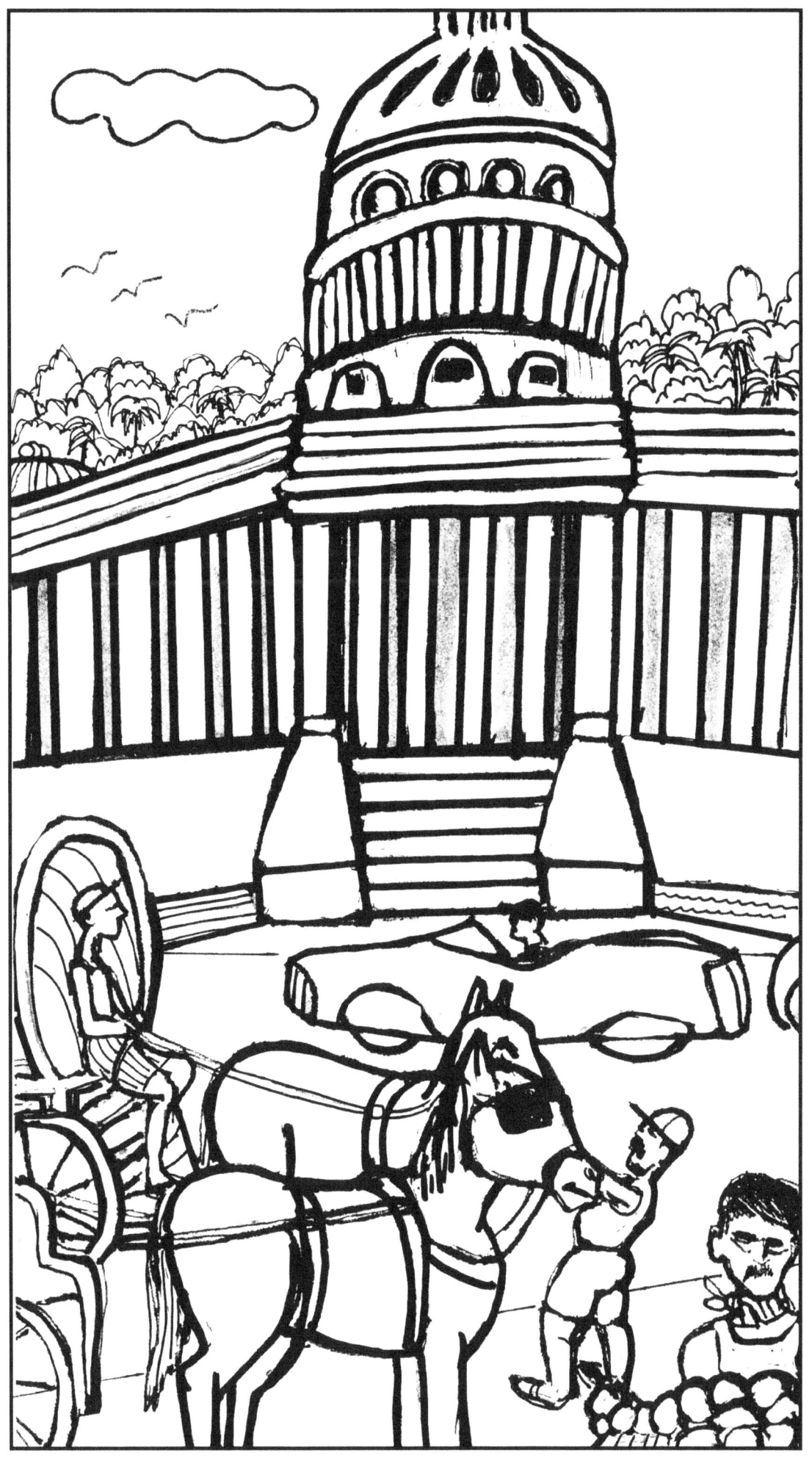

Capitolio in Havana
Look familiar?

Illustrated by Jan Baross

colored by:_____

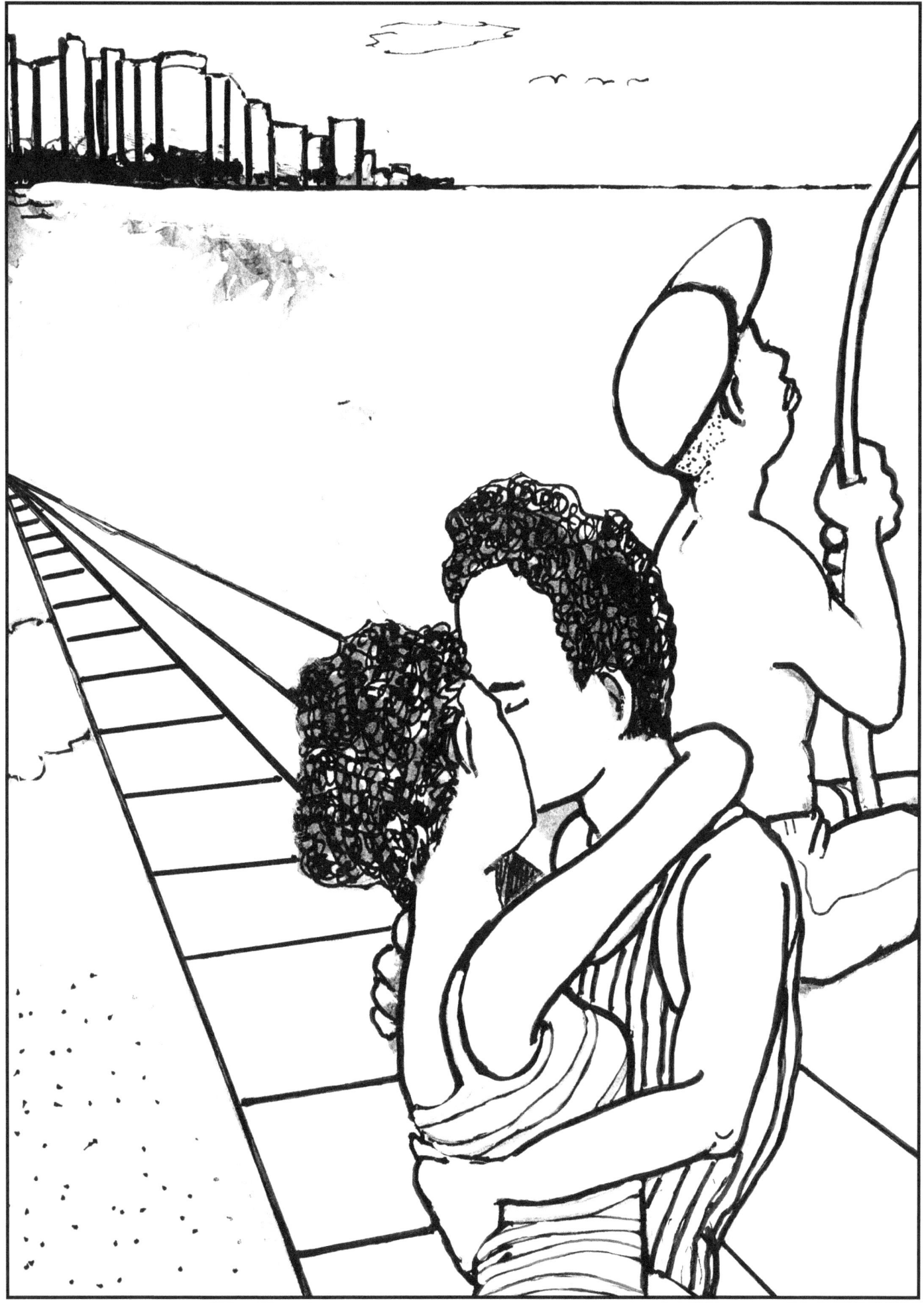

The Malecon
A cool five mile walk along the sea front.

Illustrated by Jan Baross

colored by:_____

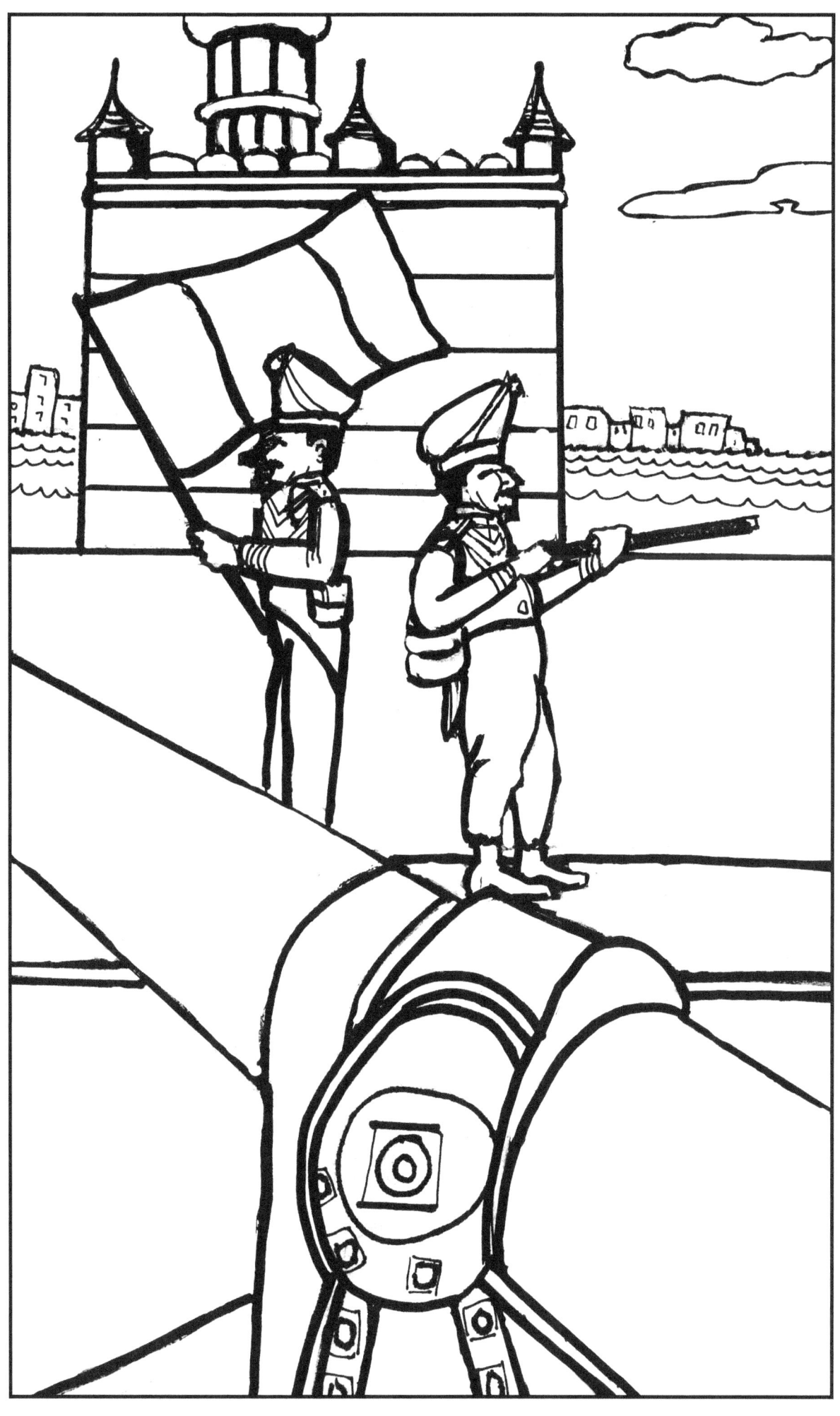

Castillo La Cabaña
Protection from pirates—A nightly re-enactment

Illustrated by Jan Baross

colored by:_____

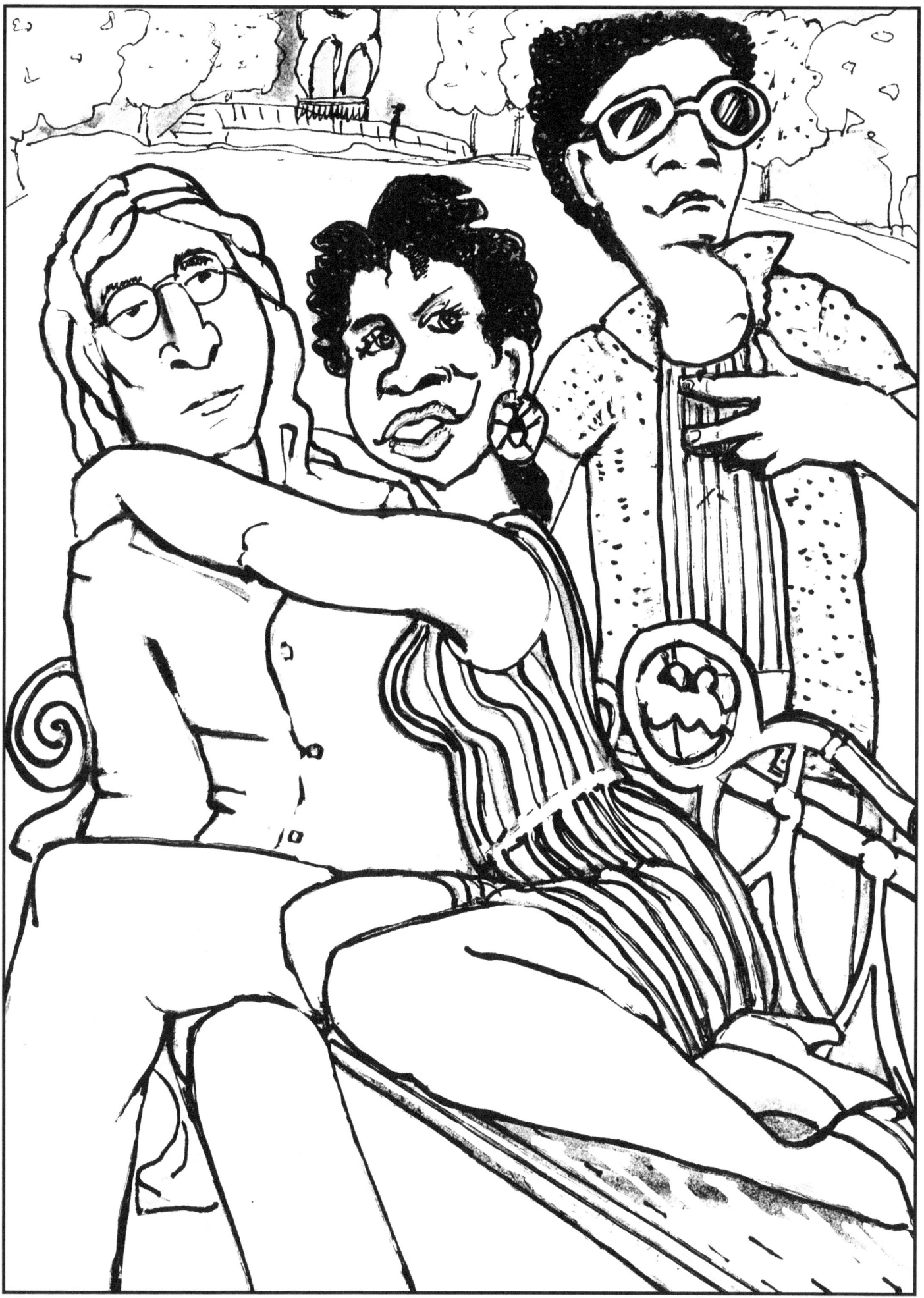

John Lennon Park
Bronze statue dedicated by Fidel Castro in 2000

Illustrated by Jan Baross

colored by:_____

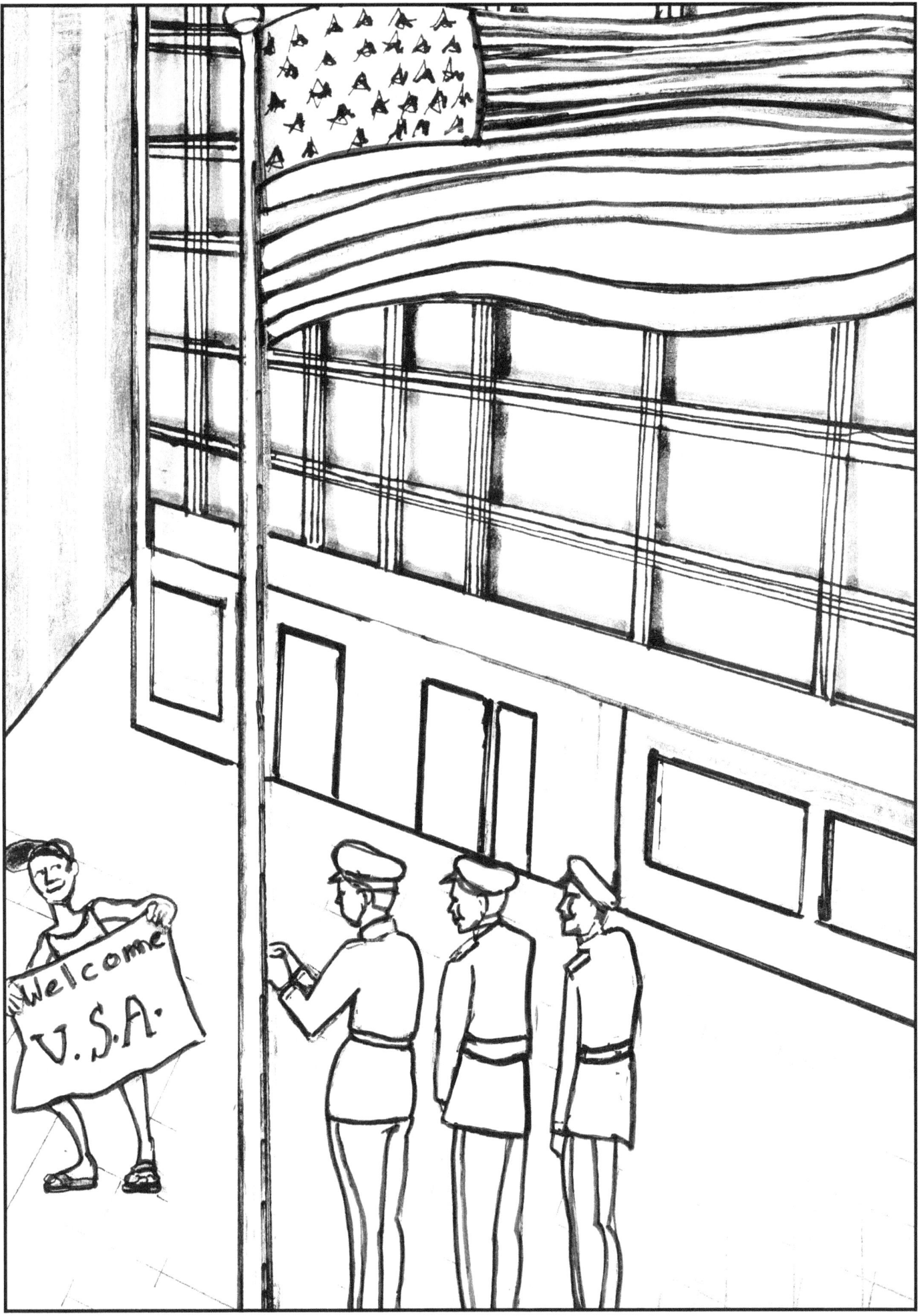

Official U.S. Embassy in Cuba
Same three marines who lowered the flag in 1961 raised it in 2015.

Illustrated by Jan Baross

colored by:_____

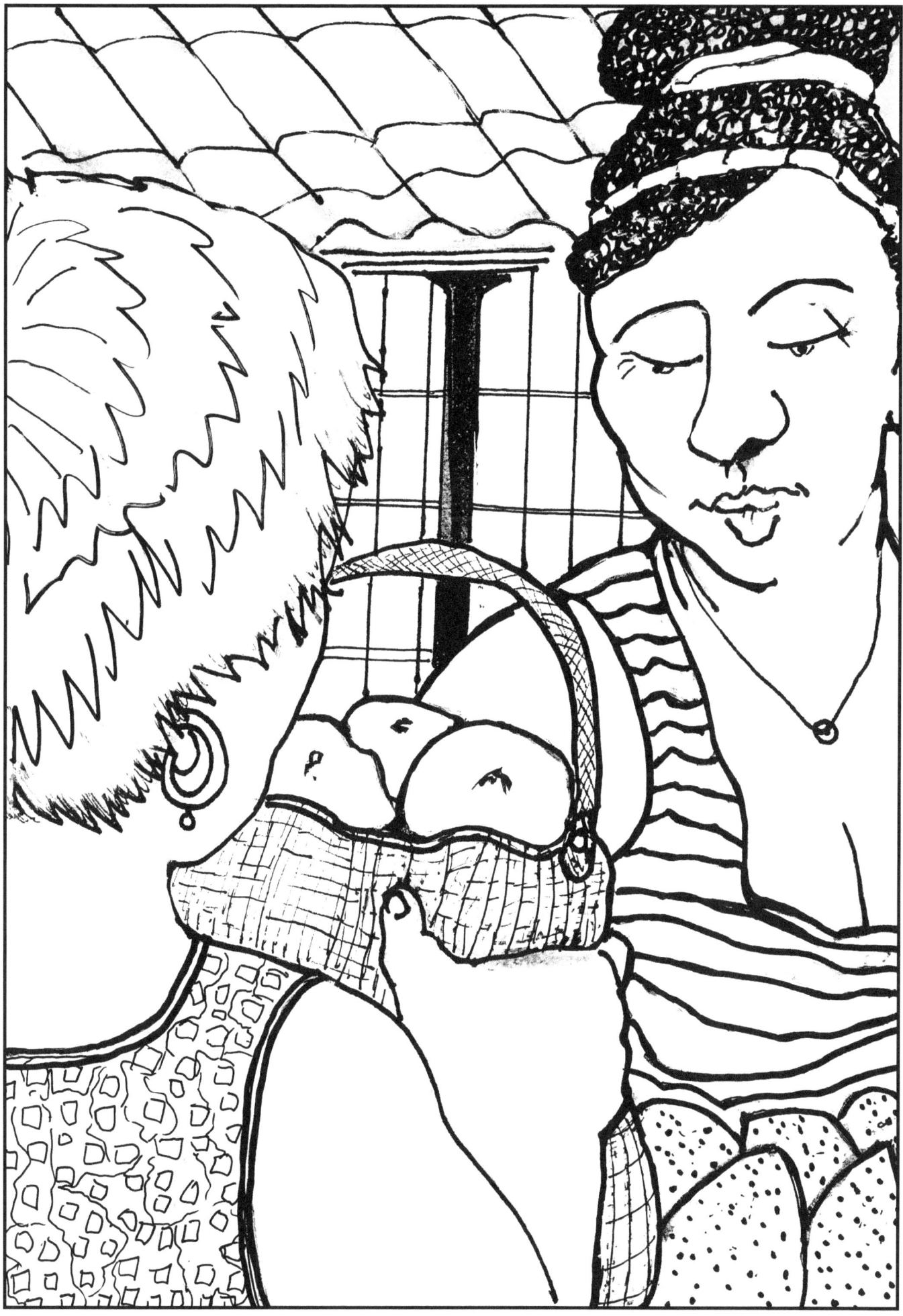

The Market
Cubans live on $25 a month and a ration book.

Illustrated by Jan Baross

colored by:_____

Palacio de Belles Artes-Fantasical Cuban Artists

Illustrated by Jan Baross

colored by:_____

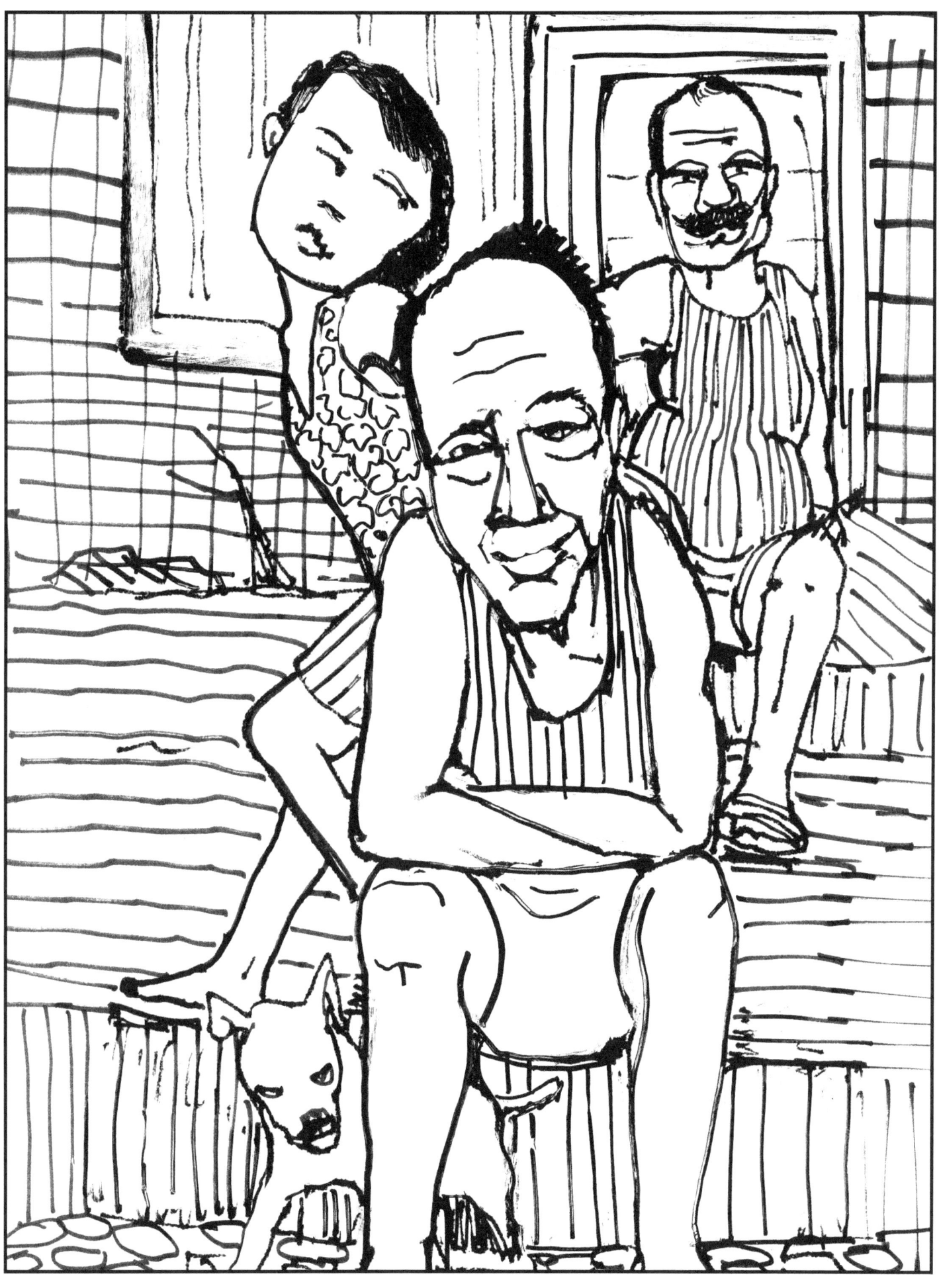

Folks in the Vedado Hood

Illustrated by Jan Baross

colored by:_____

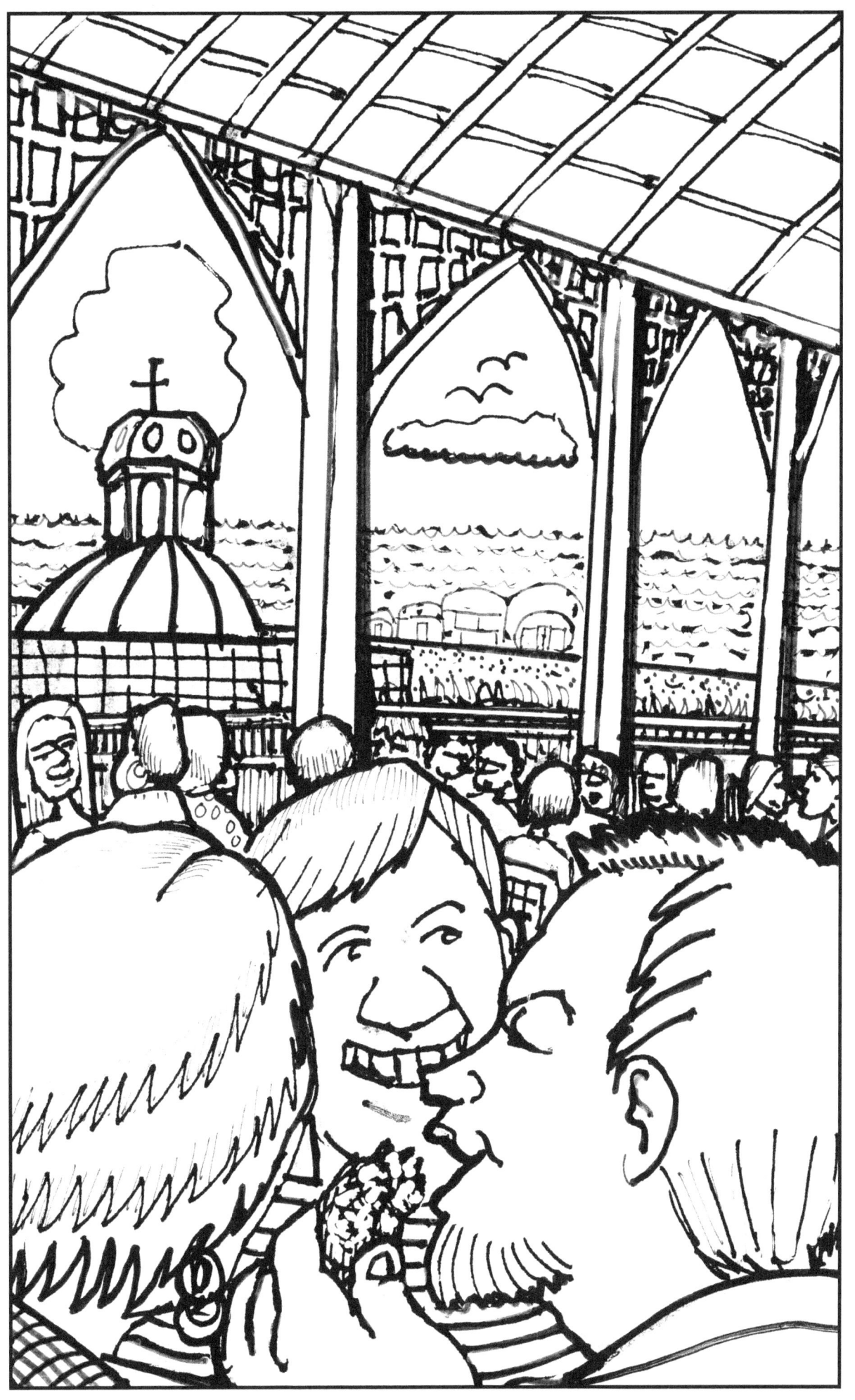

Hotel Ambos Mundos
Great View of the Town

Illustrated by Jan Baross

colored by:_____

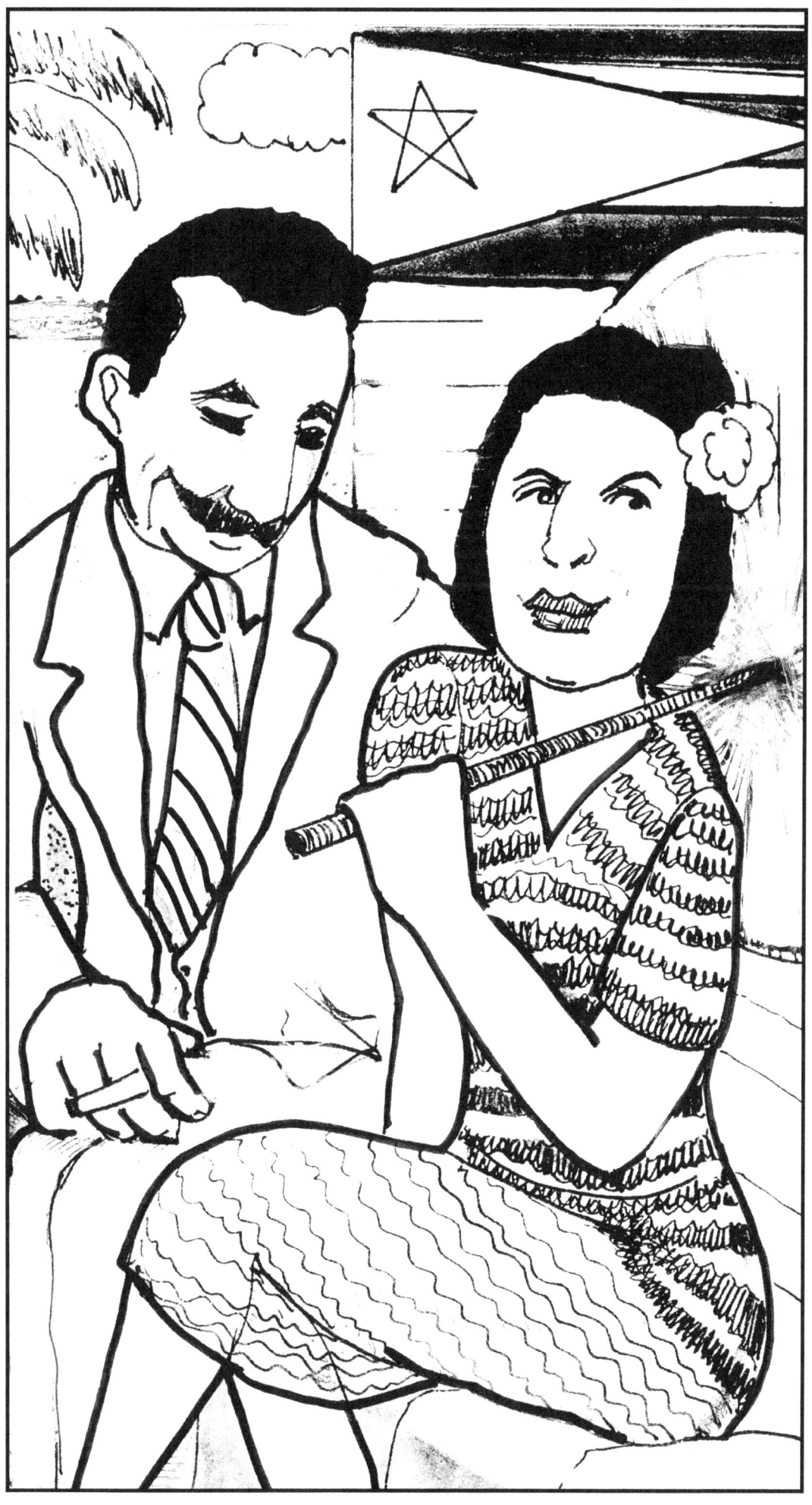

Stylish Cubans of the Past

Illustrated by Jan Baross

colored by: _____

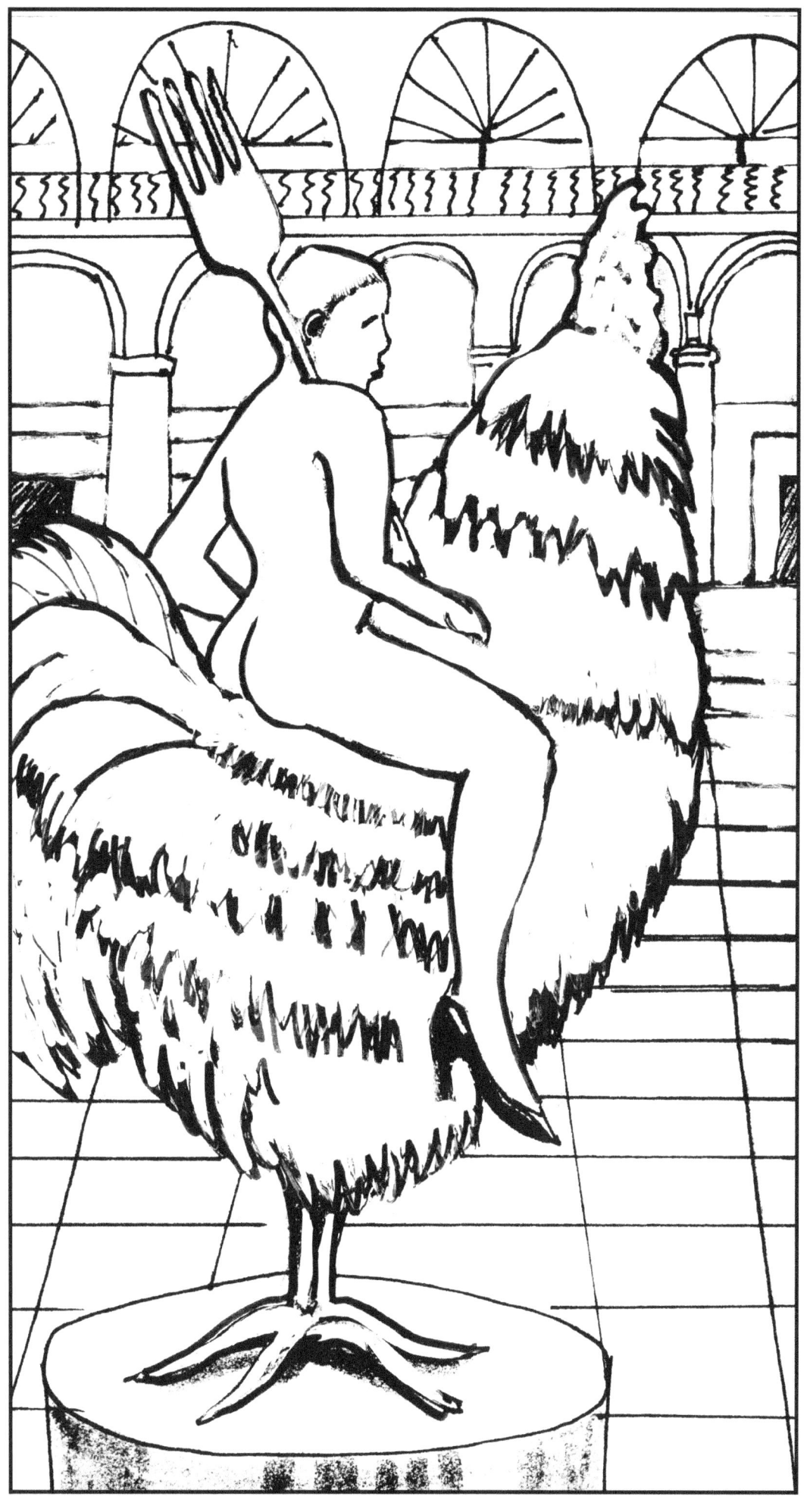

Plaza Vieja
More Wild Sculptures

Illustrated by Jan Baross

colored by: _____

Catholic Christening

Illustrated by Jan Baross

colored by:_____

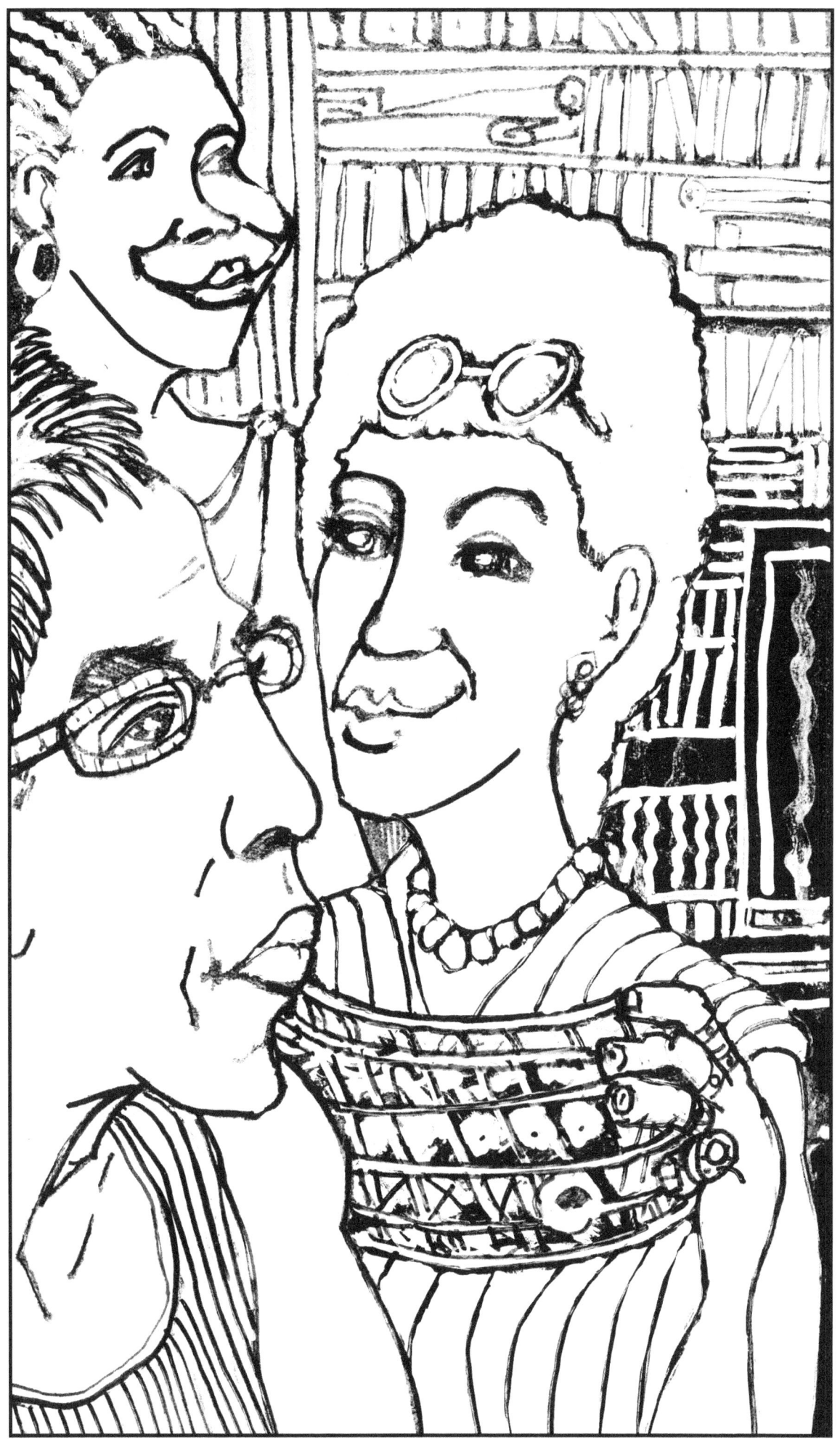

Taller Experimental de Graficà
An Art School

Illustrated by Jan Baross

colored by:_____

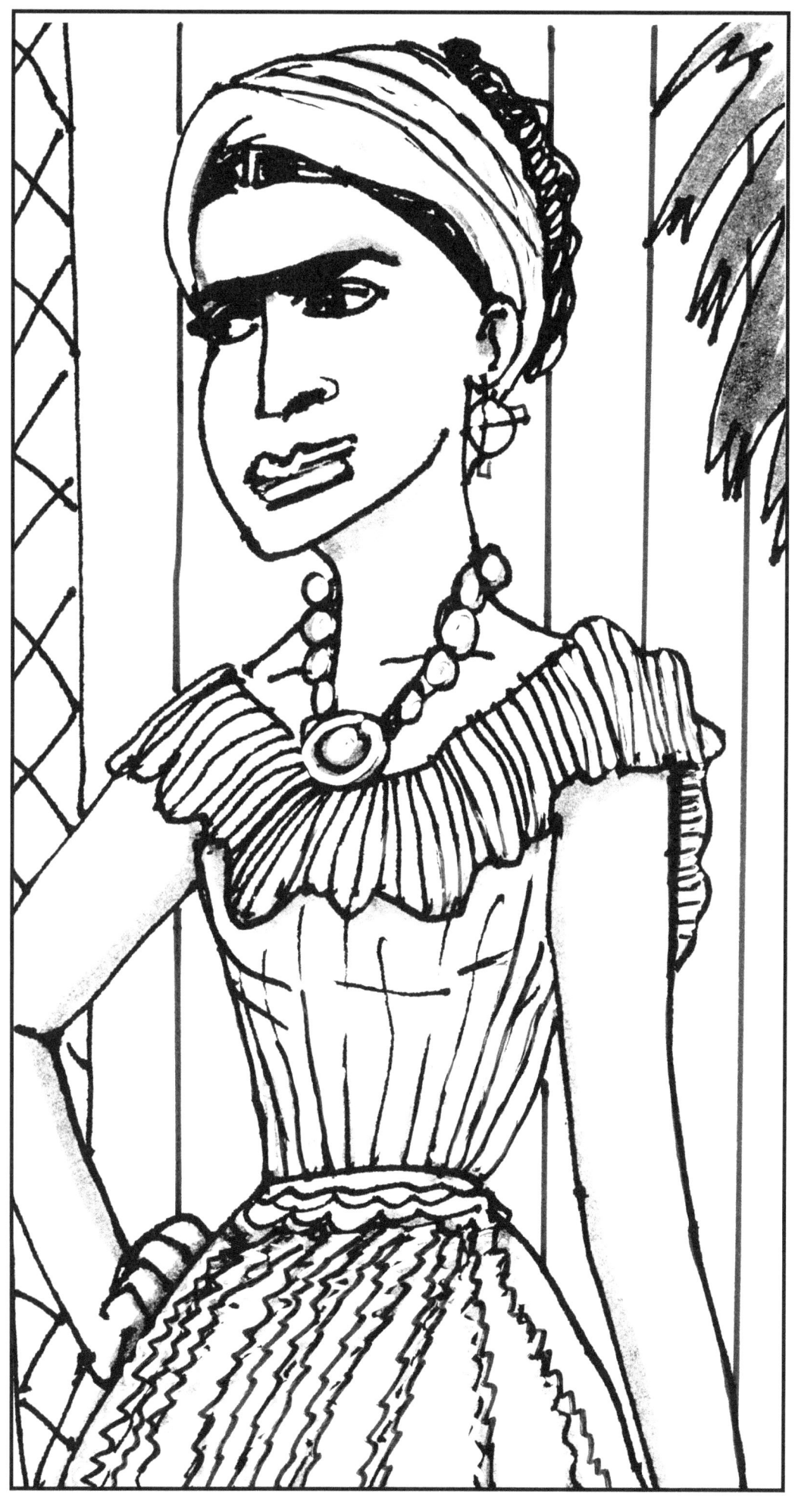

*The Cuban Fashion Show of the
Frida Kahlo Collection*

Illustrated by Jan Baross

colored by:_____

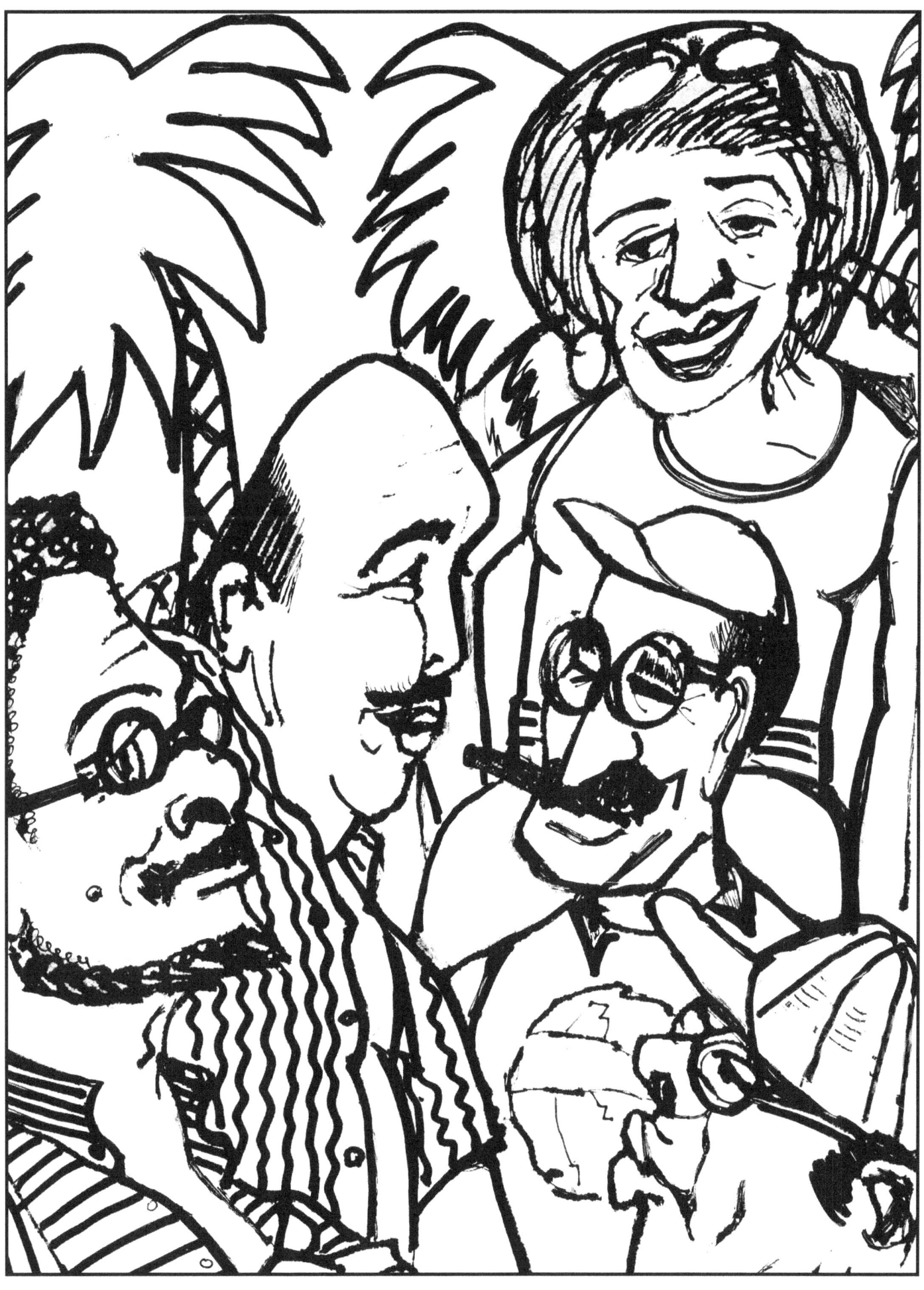

Café Life in Cuba is 24/7

Illustrated by Jan Baross

colored by:_____

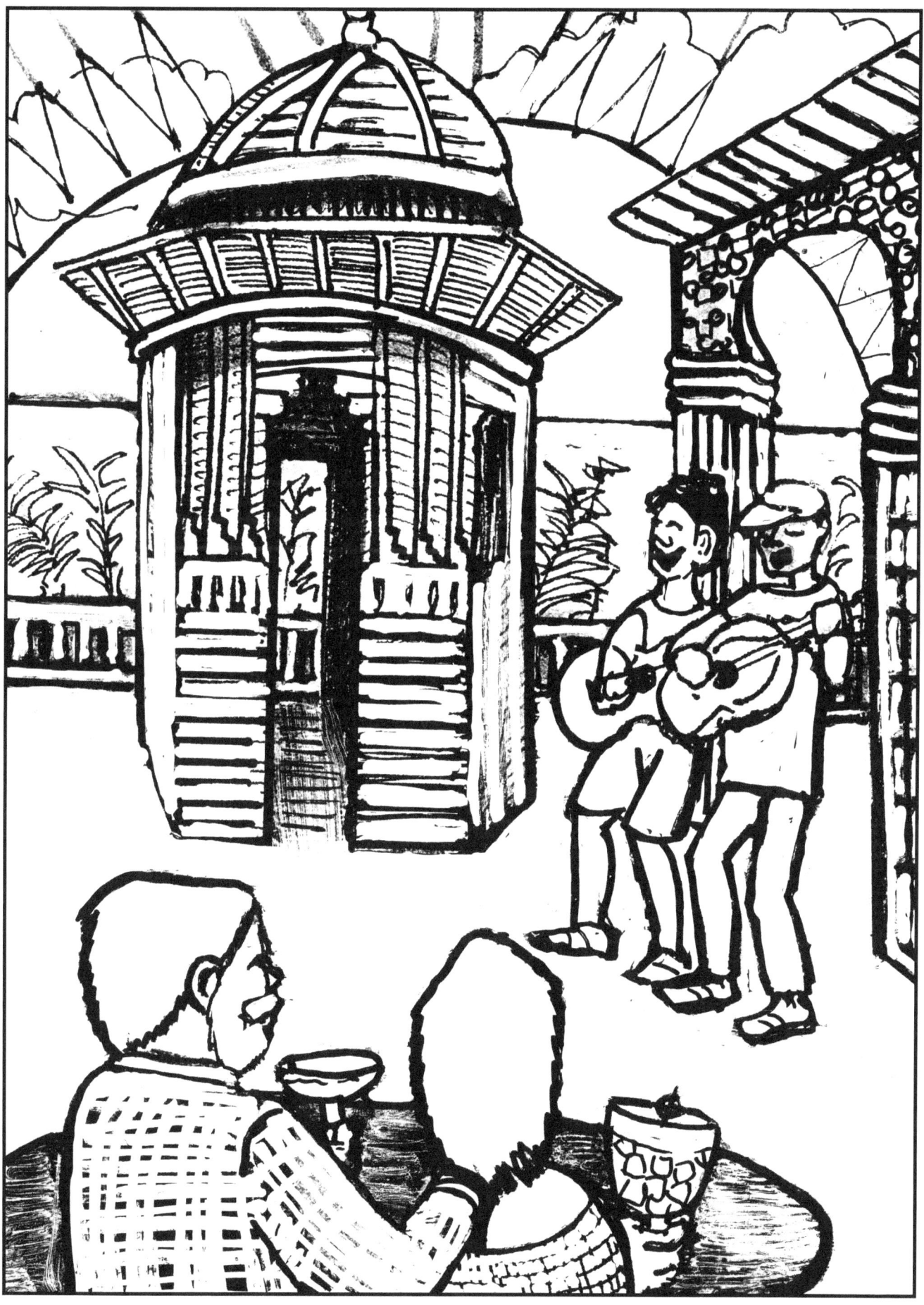

Magnificent Palacio de Valle
Cienfuegos, Cuba
Circa 1913

Illustrated by Jan Baross

colored by:_____

Hotel Granjita—Santa Clara, Cuba
Organic and Solar Powered

Illustrated by Jan Baross

colored by: _____

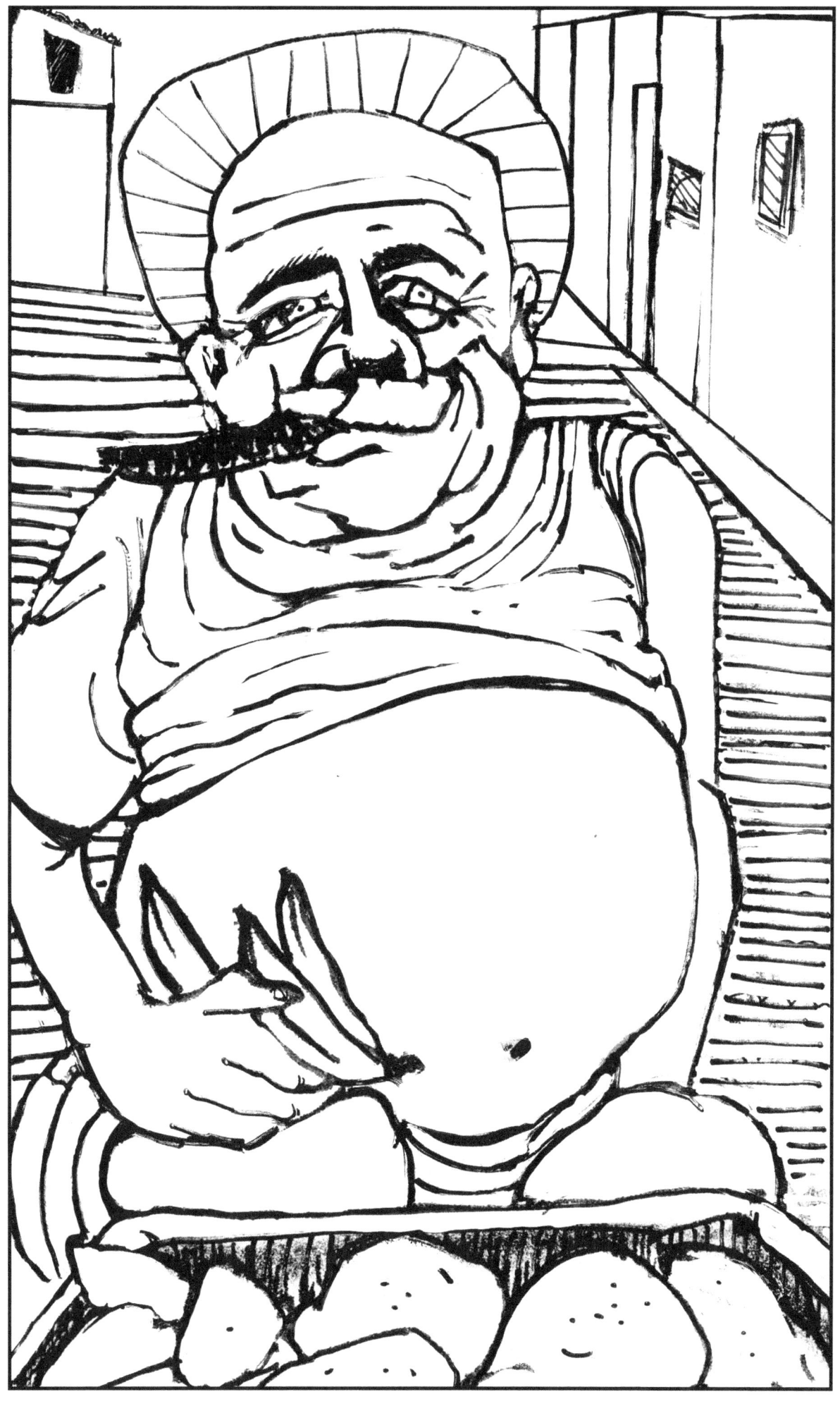

Vendor
Trinidad, Cuba

Illustrated by Jan Baross

colored by:_____

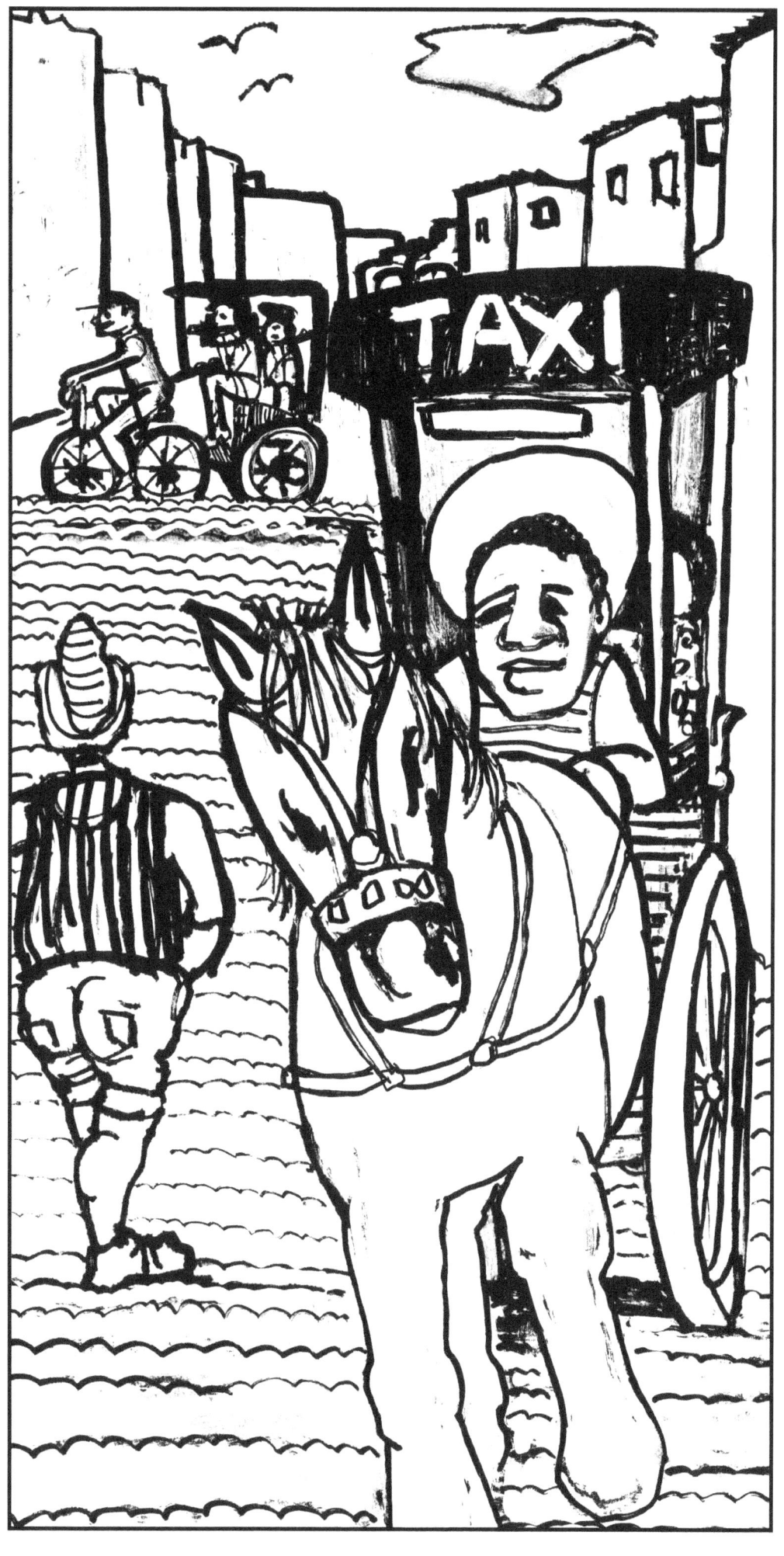

Trinidad Taxi
Cuba

Illustrated by Jan Baross

colored by:_____

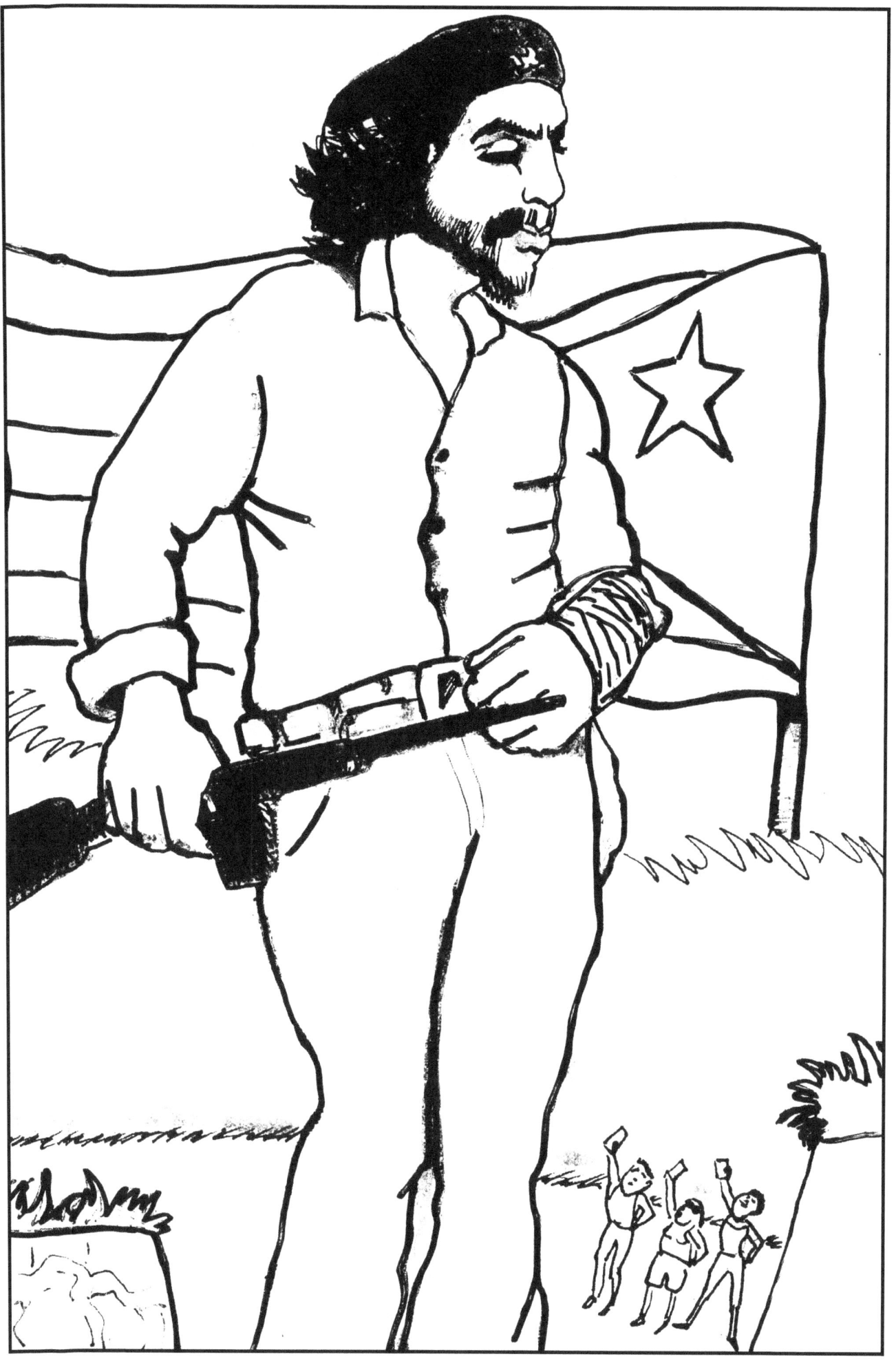

Che Guevera Statue—Santa Clara, Cuba
Where Che Won the Decisive Battle of the Revolution

Illustrated by Jan Baross

colored by:_____

www.ingramcontent.com/pod-product-compliance
Lightning Source LLC
Chambersburg PA
CBHW080544190526
45169CB00007B/2627